FASHION & SURREALISM

© 2001 Assouline Publishing for the present edition
601 West 26th Street, 18th floor
New York, NY 10001
USA
Tel.: 212 989-6810 Fax: 212 647-0005
www.assouline.com

First published by Editions Assouline, Paris, France

Translated from the French by David Wharry

Color separation: Gravor (Switzerland)
Printed by Grafiche Milani (Italy)

ISBN: 2 84323 378 X

FASHION & SURREALISM

FRANÇOIS BAUDOT

ASSOULINE

SURREALISM, n. Psychic automatism in its pure state, by which one proposes – verbally, by means of the written word, or in any other manner – to express the actual functioning of thought. Dictated by thought, in the absence of any control exercised by reason, exempt from any aesthetic or moral concern. Encycl. Philos. Surrealism is based on the belief in the superior reality of certain forms of previously neglected association, in the omnipotence of dream, in the disinterested play of thought. It tends to ruin once and for all other psychic mechanisms and to substitute itself for them in solving the principal problems of life.

André Breton, from *Manifesto of Surrealism.*

the word "surrealism," believed to have been coined by the poet Guillaume Apollinaire, first appeared around 1917. The neologism, which during the interwar period became synonymous with scandal, has since become such an everyday word that its true meaning has almost been forgotten. The Petit Robert dictionary's definition – "An ensemble of creative and expressive procedures using all psychic forces (automatism, dream, the subconscious), freed of the control of reason and in conflict with accepted values" – copes pretty well vis-à-vis the inventors of automatic writing and Breton's own definition.

In its desire to throw everything into question, the Surrealist revolution above all influenced art, with which the movement maintained a constantly ambiguous relationship. André Breton, a forceful personality and Surrealism's self-proclaimed Pope, succeeded in enlisting outstanding talents among the young adventurers intent on inventing a new meaning for the act of painting. First there was Max Ernst, who had already been discovered by Tristan Tzara and the Dada movement, Surrealism's launching pad (albeit more

nihilist than creative), then Salvador Dali, Joan Miró, Yves Tanguy, René Magritte, Victor Brauner, Roberto Matta and André Masson joined the group that emerged in Paris in the twenties.

t he idea of a parallel between fashion, with its ephemeral frivolity, and Surrealism, one of the major threads running through twentieth-century thought, might a priori seem gratuitous, even absurd, like one of the "exquisite corpses" (a game consisting in participants adding part of a sentence or drawing on a folded sheet of paper, unaware of the others' contribution) so dear to Breton and his friends. Although Surrealism was essentially a male-dominated movement, straight away the group placed a woman at the very heart of its creative process. The painter Bona de Mandiargue, born in 1926, who joined the Surrealist movement later on, in the fifties, remarked, "It was the first time I had heard intelligent people taking an interest in the woman's role without subjugating it to man's. The Surrealists didn't separate women from poetry, they identified her with their own creative process." We are no longer talking about the muse of the romantics here, or the intimate relationship between artist and model. The Surrealists regarded the loved one as sacred. Breton wrote in *Nadja:* "I am, as well as being close to her, closer to things that are close to her."
It was a short step from this adoration of woman to fetishizing her fashion accessories and items of female dress: Aragon with Elsa, Max Ernst with Leonora Carrington then Dorothea Tanning, Dali with Gala . . . Others in poetry and the visual arts also took the game quite a long way, producing several remarkable incidences between woman's anatomy and her finery. Fashion, we know, feeds

on everything and is adept at hijacking the spirit of the moment for its own profit. In the thirties it lost no time in assimilating the Surrealist vulgate, adopting its sense of provocation and systematic disjunction, its free associations and subversive breaks. Today one could even consider, given the exponential development of haute couture and then designer ready-to-wear in the 20th century, that fashion's more singular creations, worn by the modern-day fashion victim, constitute the ultimate manifestation of the "surreality" originally explored by magicians of language. They are concrete, real-life applications of Salvador Dali's concept of critical paranoia, which he defined as "a spontaneous method of irrational knowledge based on the critical and systematic objectification of delirious associations and interpretations."

I n the couturier's studio, the famous "encounter of an umbrella and a sewing machine on a dissecting table" evoked by Lautréamont in *Maldoror* reveals itself to be a perfectly ordinary occurrence, a phenomenon totally integrated into the creative process. Isn't the couturier – medium, conjurer and high priest of the transubstantiation of trends into symbols of the time – also entitled to declare, as Miró did in front of one of his canvas, "This is the color of my dreams"?

From the group's beginnings, one of Surrealism's recurrent themes, and perhaps its principal link with fashion, was that obscure object of desire, the dressmaker's mannequin. It first appeared in di Chirico's pictures in 1915, its abstract, highly stylized form symbolizing, above all, absence. Life-size mannequins, with their simulacra of life, were another obsession of the

Surrealists, one of whose favorite haunts was the Grévin wax museum in Paris. In 1938, at the Exposition Internationale de Surréalisme, organized by George Wildenstein at the Galerie des Beaux-arts, store window mannequins were given to participants for them to adorn, for them to dress up their synthetic nudity however they wished. Another vehicle of fantasy was the doll, notably those created by Hans Bellmer, which he mixed with fragments of fabric and lace.

t he tangency between fashion and Surrealism had already been put to more direct use. In 1927, the Belgian artist René Magritte was commissioned by a Brussels department store to design its fur coat catalogue and was asked to steep the furs in that mysterious atmosphere so dear to him. The venture was successful enough to be renewed the following year. Throughout his career, Magritte remained one of the great explorers of the female wardrobe. One of his ideas, to superimpose body parts onto inert garments, was adopted by leading couturiers in the late 20th century.

At the 1937 International Exhibition, the French couture syndicate organized a pavilion glorifying luxury goods, imposing a strict codification on each participant. Elsa Schiaparelli recalls that, "after a great deal of discussion, I did my display myself. On a lawn I laid a forlorn plaster mannequin, as naked as the day it left the factory, and adorned it with flowers to brighten it up. Then, I hung a length of cord across an empty space and, like a clothes line on washing day, hung the attire of an elegant woman on it – slacks, stockings, shoes, everything. No one could object: I had followed the couture

syndicate's stipulations to the letter. But in such a way that, on the first day, a policeman had to be posted to keep back the public."

The mysterious and marvelous interior of the couture house – vast accessory warehouse, machine for poeticizing life, palace of the unexpected – is, just like the surrealist realm, the domain of initiates. The couturiers' detachment from the prosaic context of worldly things, despite their repeated claims to be designing for "the street" (that mythical space somewhere between the bedroom and the pavement), their elitism and affectation, their ciphered fashion codes, everything about them tends towards surrealist metaphor – or, of course, total metamorphosis (that recurrent obsession in surrealist poetics, if not its prime preoccupation).

any discovery changing the nature or purpose of an object or phenomenon constitutes a Surrealist fact." (in *La Révolution surréaliste*). The same goes for the Surrealist taste for disguise, masks and fancy dress. Or cross-dressing: in 1920, Marcel Duchamp transformed himself into "Rrose Sélavy" to publicize a perfume he had invented, Belle Haleine – Eau de Violette, following this up with a string of equally dubious plays on words such as *cuisse enregistreuse*, *objet dard* and even *dos de la cuillère au dos de la douairière*, an almanac of *mot verts* (risqué puns) designed to aggress the reader. From now on, the dress shrinks away to clothe the naked.

Haute couture Surrealism reached its high point shortly after World War II in Paris, where several designers, certain that they had nothing left to gain from respectability, began behaving as if they had nothing left to lose either. The Paris of the thirties was a

particularly creative context for them. Absurdity was in the air. "Since these mysteries are beyond us, let's feign being their organizers," wrote Jean Cocteau. De facto, many second generation Surrealists came from the crème de la crème of a society craving novel entertainment: viscount and viscountess Charles de Noailles, Valentine and Jean Hugo (a descendent of Victor Hugo), the American millionaire Peggy Guggenheim, Gabrielle Chanel and, above all, her arch-rival Elsa Schiaparelli, all fully adhered to the theories postulated by Breton. They expressed their originality in jewelry, finery, ornaments, themes for fancy-dress balls, evening dresses, etc. Paris was still one long party, these were unreasonable times. The Surrealists had established sex and death as acceptable subjects of dinner conversation. Between cocktail parties, Charles de Noailles financed Louis Bunuel's film *L'Âge d'or*, for which he was excluded from Paris's elite Jockey Club. What did it matter? He and his wife commissioned the architect Robert Mallet-Stevens to design them a Cubist villa at Hyères on the Mediterranean coast. Man Ray chose this strange setting as the location for his film *Le Mystère du château de dés*. Then, in 1927, he transformed the curvaceous figure of his mistress Kiki de Montparnasse into a viola-odalisque tattooed with demisemiquavers in *Le Violon d'Ingres*.

When Man Ray took this photograph, he was living with Kiki in a studio in rue Campagne-Première on the Left Bank. Most of the Dadaists and later the Surrealists visited him there. He took their portraits, nobody paid him but everyone was happy, and the American accumulated an impressive photo album and his reputation spread – at least in

the art world. Jean Cocteau, a poet considered second-rate and officially scorned by André Breton, invited Man Ray to photograph him at home, in his bedroom surrounded by fetish and droll objects. The poet then sent prints of the portrait to his prestigious acquaintances. And so Man Ray became fashionable before the fashion world got its hands on him. He already earned a living from his portrait photography but, to his great regret, his paintings and photographs full of dizzy fantasy met with little more than polite assent from his entourage. Then the couturier Paul Poiret, famous for his generosity and his collection of avant-garde paintings, became interested in Man Ray's photographic work. And as the photographer also took an interest in beautiful fashion models – he succumbed. Poiret's stamp of approval opened the doors of rival houses and the most prestigious fashion magazines for the photographer. And it was during his bread and butter work for Poiret that he accidentally stumbled on a technique enabling him to take photographs without a camera: his famous "rayograms," which instantly fascinated first Tzara then the Surrealists.

the young woman with a slender, athletic, slightly androgynous figure who became Man Ray's assistant in the late twenties and later his muse in the Surrealist Paris of the next decade, was also from the fashion world. In 1927, Lee Miller was crossing a street in Manhattan when she was nearly run over by a speeding car. She managed to jump out of the way just in time and landed in the arms of none other than the new sultan of the magazine press, Condé-Nast. He took one look at her and invited her to come and pose in the *Vogue* studio just round the corner.

Next month, twenty-two year old Lee Miller was on the cover of the top fashion magazine of the time. She had a glorious career as a top model in front of her but her ambition was to go to the capital of artistic life, Paris, to try her hand at photography. Edward Steichen gave her Man Ray's address and one morning she rang the bell at 31, rue Campagne-Première. The small man who answered the door, who was leaving on holiday that day, couldn't believe his eyes – or his ears when the celestial beauty on the doorstep asked him if she could go with him. They lived together for three years. By day Lee pursued her career in the couture houses, posing for the greatest photographers of the time, by night she modeled for Man Ray. In exchange he taught her the rudiments of photography, so well that in ten years time she had become both a heroic war correspondent and a sought-after portrait photographer. In the meantime, Man Ray had sold one of his own artworks to one of the great collectors of modern art, the tsarina of beauty creams, Helena Rubinstein.

but paradoxically, the prince of fashion who took the most interest in Surrealism was one of the doyens of the profession, Jacques Doucet. Born in 1853 he had forged his reputation in fin-de-siècle Paris and by the dawn of the 20th century was the owner of a couture house that had become synonymous with supreme elegance. He had amassed a sumptuous collection of 18th-century furniture and artworks, which he kept in his mansion near the Bois de Boulogne. And then, suddenly, he got rid of it, and for reasons that remain unknown, from that point on took an increasing interest in contemporary art. First

Cézanne, Van Gogh and Degas then Henri "Le Douanier" Rousseau (*The Snake Charmer*), Picasso (*Les Demoiselles d'Avignon*), di Chirico (*The Return*), and later Max Ernst, Juan Gris, Masson and others. He hired André Breton to help him with the exceptional library of manuscripts he was acquiring. Breton was soon joined by Louis Aragon and then the poet Pierre Reverdy. Although his classicism contrasted oddly with his tastes as a patron of the arts, without ever neglecting his business, "Monsieur Jacques," as his female clients invariably called him, spent the last years of his life enjoying the company of close friends such as Marcel Duchamp and Francis Picabia, two pioneers of the Dada movement.

●

In her memoirs, *Shocking Life,* writing about herself in the third person, Elsa Schiaparelli recalls her débuts. "And so Schiap took her screens and set up shop at no. 4 rue de la Paix. She arranged it so that it looked like a boat, with rigging on which scarves, belts and jerseys created a jumble of color. On the sign at the entrance she wrote 'For about town – For the evening.' She had the slogan painted on a small van, in black on white writing paper. Patent leather curtains, dark wooden furniture, a map of the Basque coast painted on the white wall in bright greens and blues, completed the shop interior." Around that time, "Schiap" designed a tiny knitted hat that looked like a tube but which when worn took all kinds of shapes. The Hollywood star Ina Claire, renowned for her elegance, adopted it immediately and launched the vogue. An American manufacturer bought the design, called it the "mad cap" and made millions out of it. Straight away, this

headstrong woman with her natural propensity for eccentricity, had entered into the universe of "designer surrealism," that was all the rage in the late thirties. It was as if the finely tuned machine of Parisian luxury was already overheating with the approach of the horrors of World War II.

I n 1935 Elsa Schiaparelli (born in Rome in 1890) moved her couture house to Place Vendôme where, among many chic et choc creations, she launched the telescopic dress, the crayfish button, the col de cygne, the lamb chop hat, and the most famous of them all, dreamt up for her by Dali and Gala, a hat in the form of a high-heeled shoe. Schiaparelli was drawn to Surrealism by her natural fancifulness. She gave Jean Schlumberger his first break, and in the fifties in New York he became one of the greatest jewelers of the 20th century. Among other famous garments defying common sense that "la Schiap" (as she was nicknamed by *le tout Paris*) produced in the interwar years was the manteau-bureau suit, whose numerous pockets simulated drawers, and silk blouses printed with red ants or wasps, or even painted with trompe-l'oeil rips. Vertès painted one of Schiaparelli's fetish hairstyles, a nest with a hen sitting on her eggs, for the cover of a 1935 issue of *Vogue*. Schiap maintained a close relationship with many contemporary artists, some of whom enriched her collections in a striking fashion. The launch of each of her perfumes was always an opportunity for her to make an impact in the media.

Shocking, a fragrance for the woman determined not to go unnoticed, came in a dazzling fuchsia pink wrapper whose color immediately became synonymous with the perfume. The bottle took the

buxom form of Mae West's naked bust, a bouquet of flowers on her head and a dressmaker's tape measure round her waist. Shocking was an immediate, huge, irrepressible success. Without any advertising at all, the perfume, along with its color, became an overnight classic. Dali dyed a stuffed polar bear "Shocking pink" and put drawers in its stomach. Edward James, an eccentric Englishman who resembled David Copperfield, had given the bear to Dali, and Bettina (the director of the couture house) had borrowed it to decorate her shop, dressing it up in an orchidée satin coat and decking it with jewels. One day, when the shop was full of clients, Edward walked in and when he saw the bear burst into tears. His grandfather had killed the polar bear in the Arctic and it had been in his family's living room throughout his childhood. "Customers hurrying up and downstairs were stupefied at the sight of this cherub hugging a huge pink bear, crying his heart out. Afterwards, the young man got it into his head to decorate the shop front. He draped himself in colored fabrics and sat motionless like a Buddha in the window. He found the crowd that gathered outside to watch this new performance of his so amusing it took hours to persuade him to leave."

Schiaparelli soon launched *Sleeping*, with equal success. Alluding to the world of sleep so dear to the Surrealists, it took the form of a torch, and its wrapping, in midnight blue silk, an extinguisher. Dali designed the bottle for Schiap's perfume *Le Roy Soleil*. In 1939, for the bottle of *Snuff*, an eau de toilette for men, Schiap chose the form of a pipe – just like the one Magritte had painted ten years earlier, accompanying it with the enigmatic inscription "This is not a pipe."

A close friend of Jean Cocteau, Christian Bérard, Salvador Dali and many others, Elsa Schiaparelli, more than anyone else, truly understood that the act of shocking was part and parcel of any new idea. Today we take fashion so much for granted that we are no longer surprised by anything. But in 1935, the letter S, the designer's initial and also the fetish first letter of each of her perfumes, stood for, above all, *scandale*. A word which Surrealism imbued with all the meaning it has today.

To both charm and shock, to dazzle and surprise, to privilege the singular to the detriment of the commonplace . . . Schiaparelli applied André Breton's maxim that "beauty will be convulsive or will not be at all" to the letter. But she never took herself too seriously. She wrote in her autobiography, *Shocking Life:* "Two words are taboo for me: impossible and artist."

t oday, the most surrealist thing about a dress by a top couturier is often its price. Nevertheless, in the second half of the 20th century, designers have appropriated certain of the early Surrealist themes. In 1969, the sculptor Claude Lalanne, a friend of Yves Saint Laurent, created a bust in gilded metal specially for one of the couturier's fashion shows. The breasts were the exact shape of the breasts of the model who wore the long dress in midnight blue silk crepe.

Fashion has always played at artistic tit for tat. Louise Bourbon's 1938 curly endive salad beret, for instance, or Germaine Vitu's lettuce hats in 1941. And in 1930 Marcel Rochas had designed a jacket in trompe-l'oeil tiles. Not to forget the buttons in the form of lips, seashells, grasshoppers, butterflies and indecipherable refuse

designed for couturiers by Line Vautrin. There have been "back-to-front" and "upside-down dresses, even "inside-out" ones. Léonor Fini, Alexis Brodovitch, Miguel Covarrubias, and Giorgio di Chirico painted hat boxes, and several of these artists' illustrations appeared on the covers of prestigious magazines such as *Vogue* and *Harper's Bazaar.* The painter and poster artist Cassandre draped his women in metaphysical drapery in strange fabrics laden with overtones. Dali drew the *Eye of Time,* with diamond eyelids and a clock face iris, and also a ruby kiss with pearl teeth. And of course there is the unforgettable heart he designed for Tiffany that beats thanks to a mechanism concealed inside a nugget of crude gold from which flows, like drops of blood, a stream of rubies.

f rom fashion worn to fashion represented, from couture to the image it projects, Surrealism has never stopped exerting a capillary influence on numerous brands, on their visual material and on every aspect of fashion publicity. In so doing it has influenced fashion illustration, advertisement, fashion show mise en scene and, of course, fashion photography. The latter drew heavily on the domain of the strange throughout the 20th century: Man Ray, of course, but also Horst P. Horst, Cecil Beaton, George Hoyningen-Huene, Erwin Blumenfeld, Maurice Tabard and several others all repeatedly indulged in disconcerting imagery such as metaphysical perspectives, the play of mirrors or enigmatic simulacra, etc. They eluded photographic convention and the camera's objectivity, enriching it with new discoveries, poetry and surreal symbols. For instance, in 1937, Man Ray photographed a dress by Lucien Lelong presented in Oscar Dominguez's silk-lined wheelbarrow.

Another Surrealist act: in the sixties, when the ever-active Salvador Dali, in the manner of Andy Warhol thirty years later, was invited by the jeweler Tiffany to decorate the façade of the illustrious shop on New York's Fifth Avenue, he simply threw a paving stone throw the window. To the delight of the press, of course, specially invited for the occasion.

"I'm wearing nothing underneath," was the message written in Ben's famous handwriting, in white on a black dress by Jean-Charles de Castelbajac in 1984. A few years earlier, in 1979, Hubert de Givenchy had scattered embroidered women's lips over a black bolero. The same year Thierry Mugler had his models wear false finger nails in gilt bronze, curved like feline claws. And Pierre Cardin designed a pair of shoes molded from a man's foot, a barely veiled allusion to Magritte's painting, *The Red Model* (1935).

a distant descendent of this Surrealist subversion, of which English eccentricity still bears the trace, is John Galliano. At the dawn of the 21st century, he presented a collection whose impeccably cut dresses, lacerated with a craft knife, had tea strainers, chains and tools hanging from them instead of accessories. The show caused one of those press sensations for which the fashion world seems to have the secret.

The first Surrealists, in their seminal purity, were of course not directly concerned by the universe of fashion. The goals of the revolution they embarked on lay elsewhere. But the great intellectual movement they set in motion continues to manifest itself

today in details and secondary instances and in those little acts of daily insurrection that make Surrealism a modest manifestation of of the strange.

W oman is man's future," wrote Aragon. Clairvoyant muse, castrating wife, enchanting young witch, mirror for every fantasy or fairy godmother who uses fashion to cast her spell . . . ? Surrealism's "machine to capsize the mind," with its inherent ritual, is still influencing us almost a century after it was first formulated. It may possibly even be what is best about today's fashion — which is less worn than exhibited. Contemporary fashion questions less than it cries out at us, surprises less than it distracts. It combines quest and desire, hope and reality, those essential engines of a hypothetical yet definitive sexual liberation.

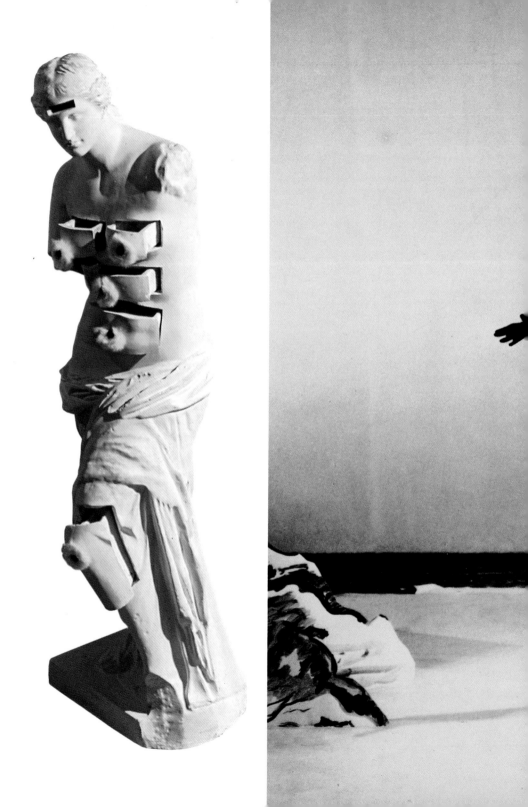

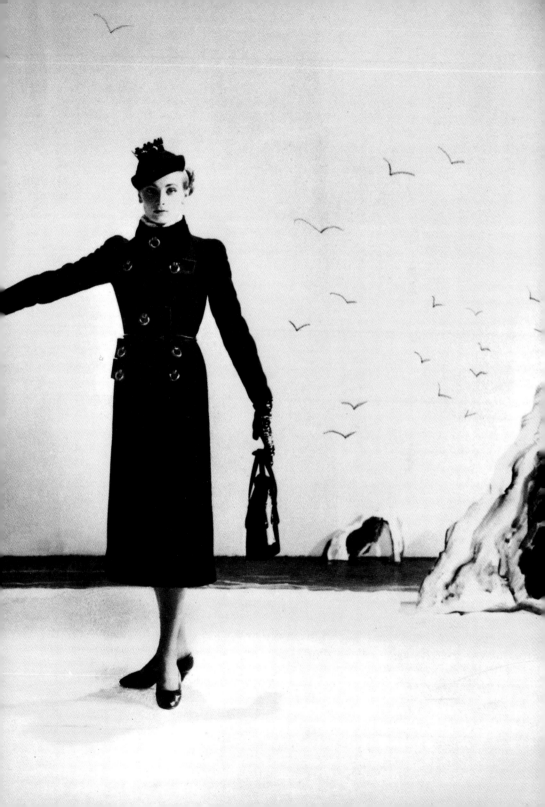

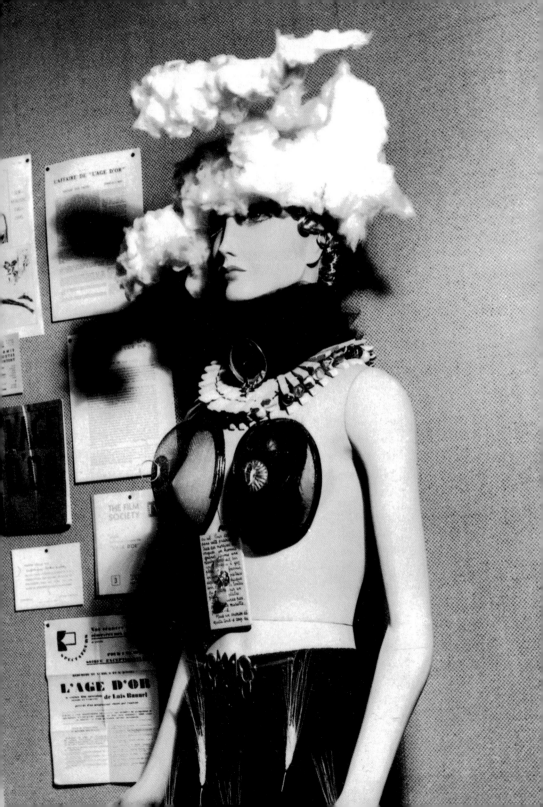

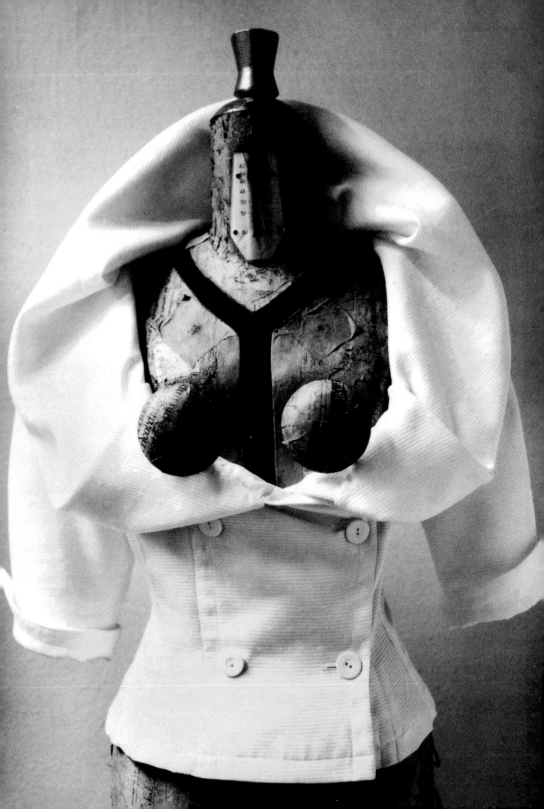

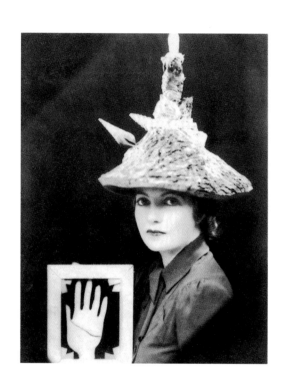

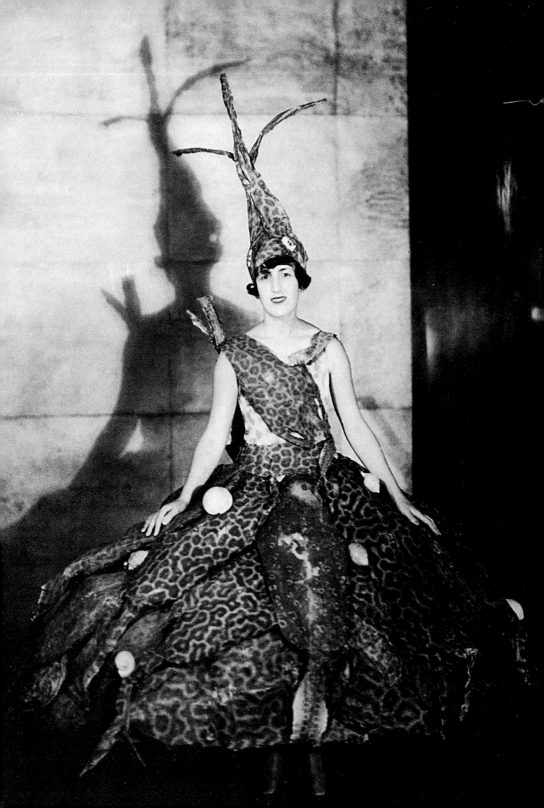

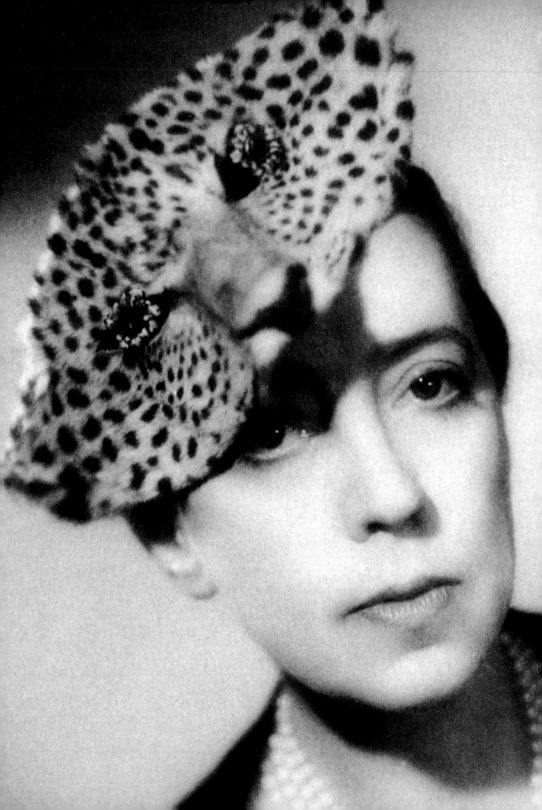

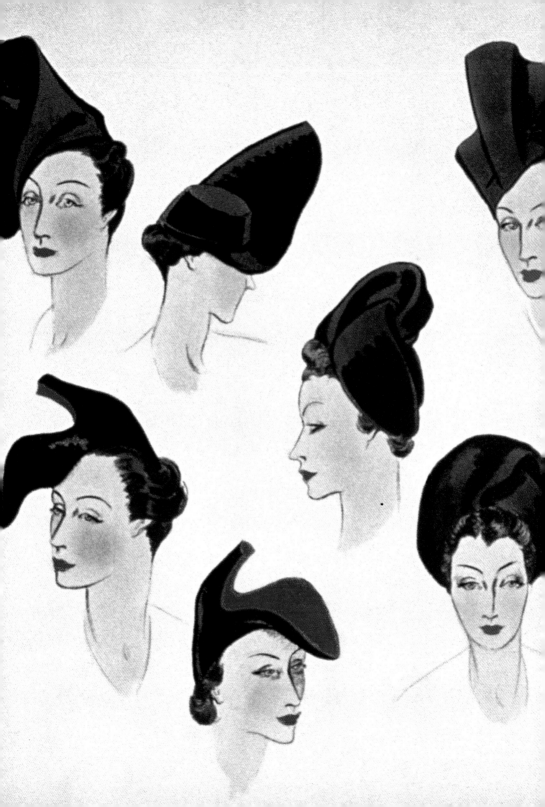

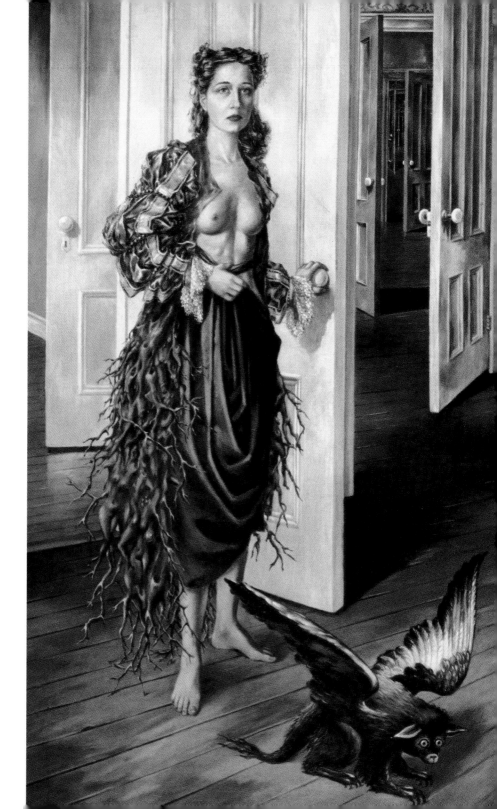

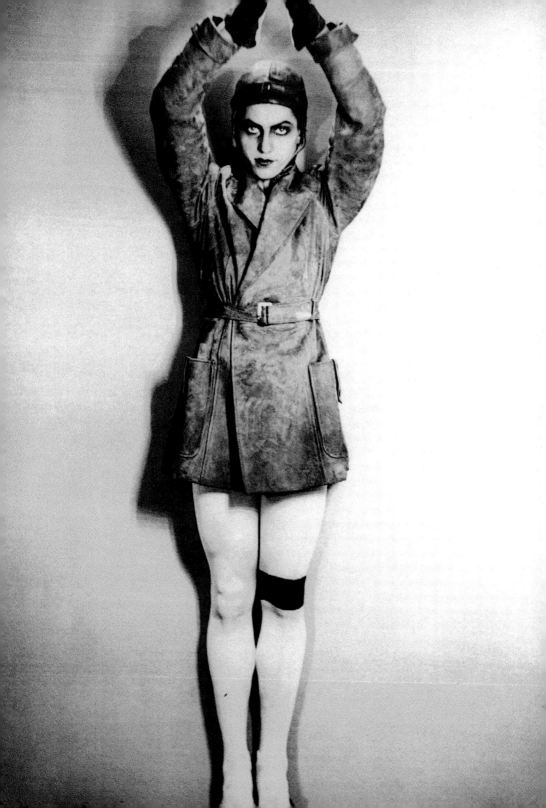

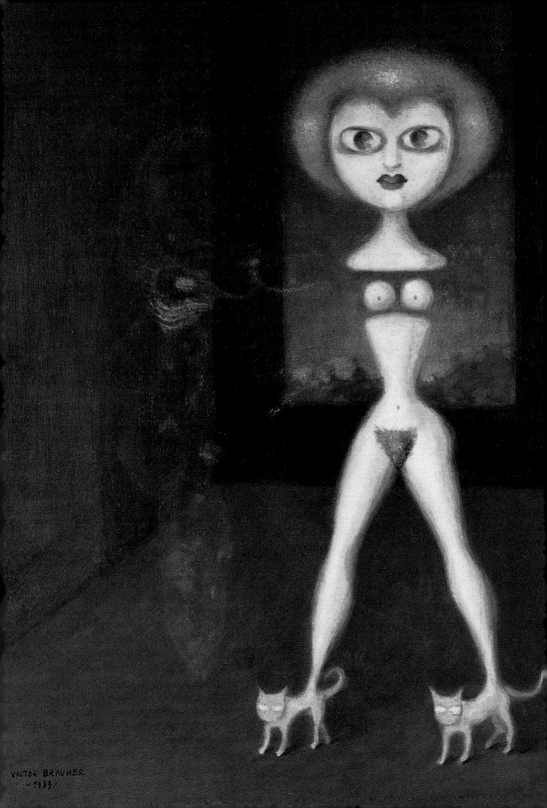

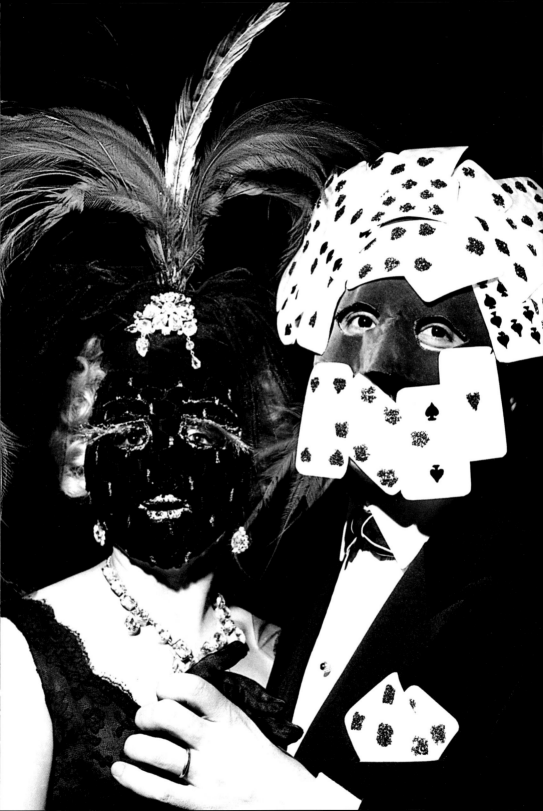

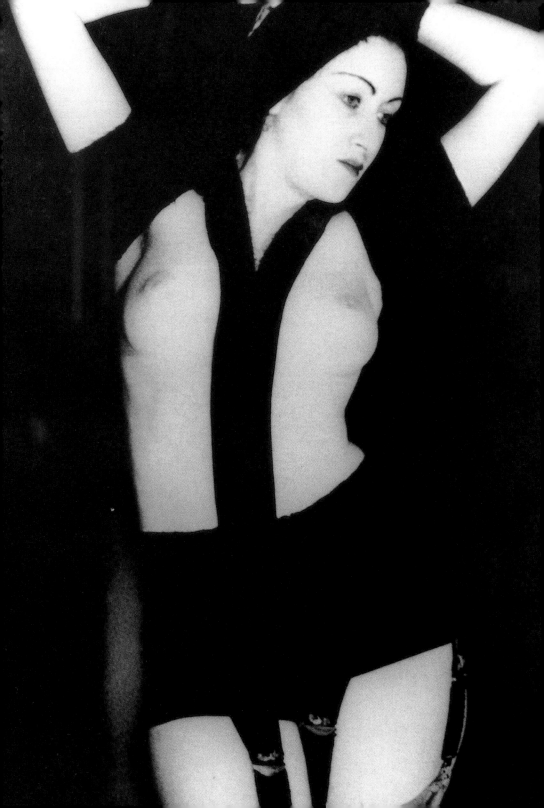

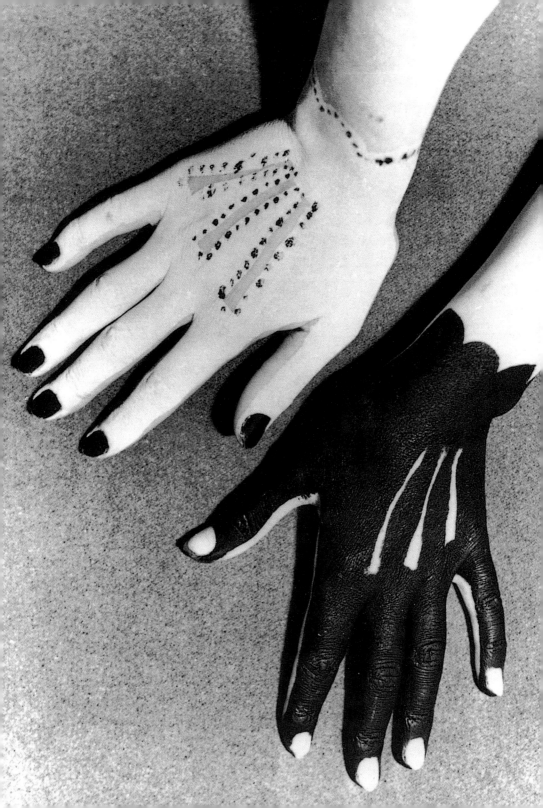

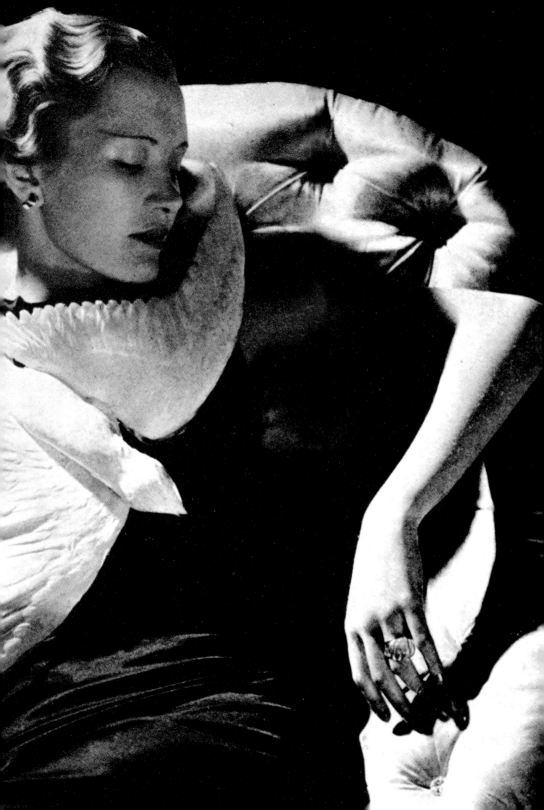

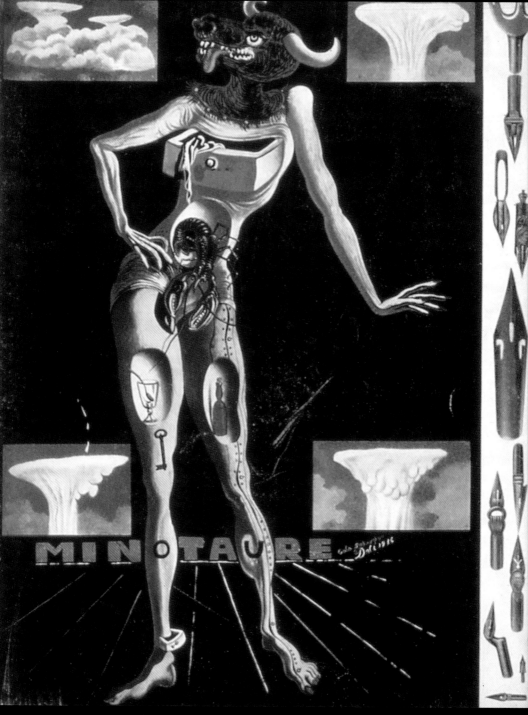

MINOTAURE

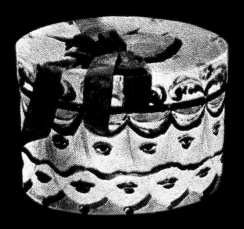
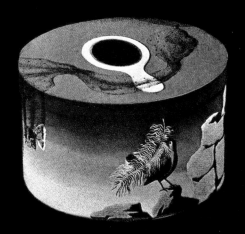
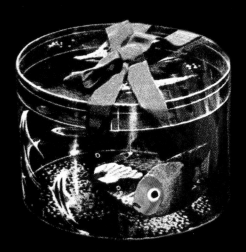

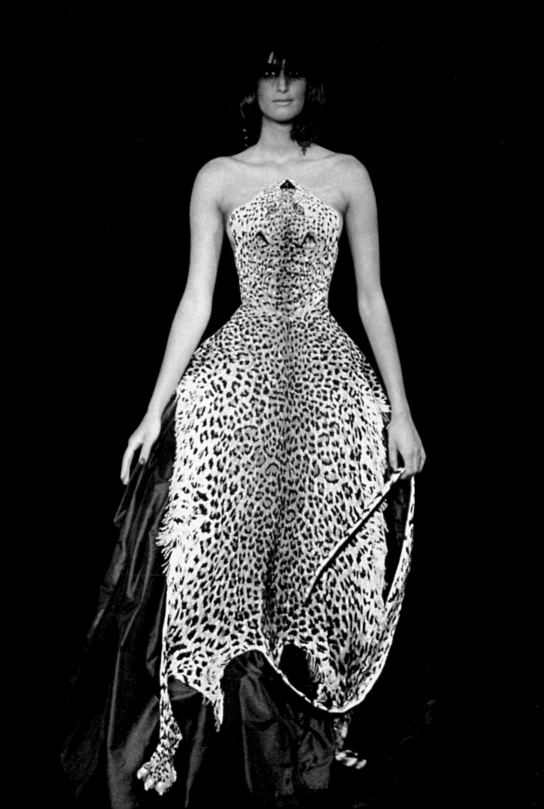

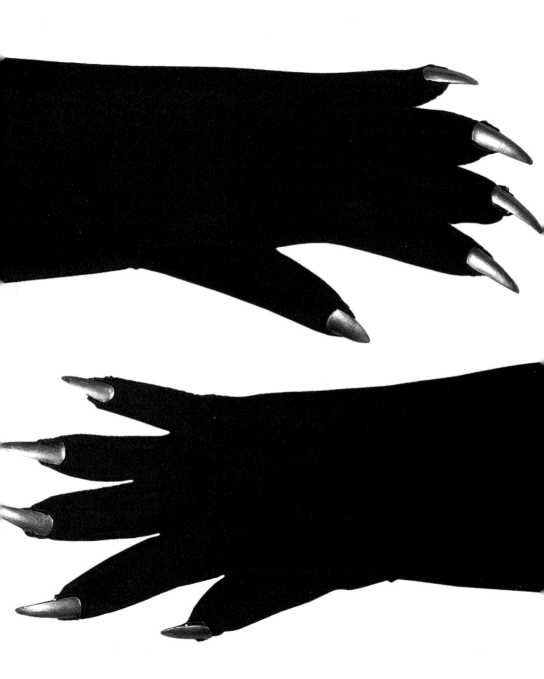

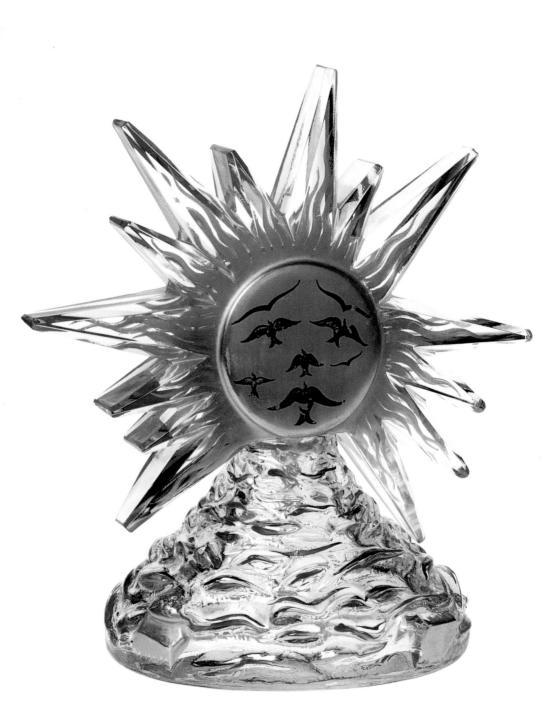

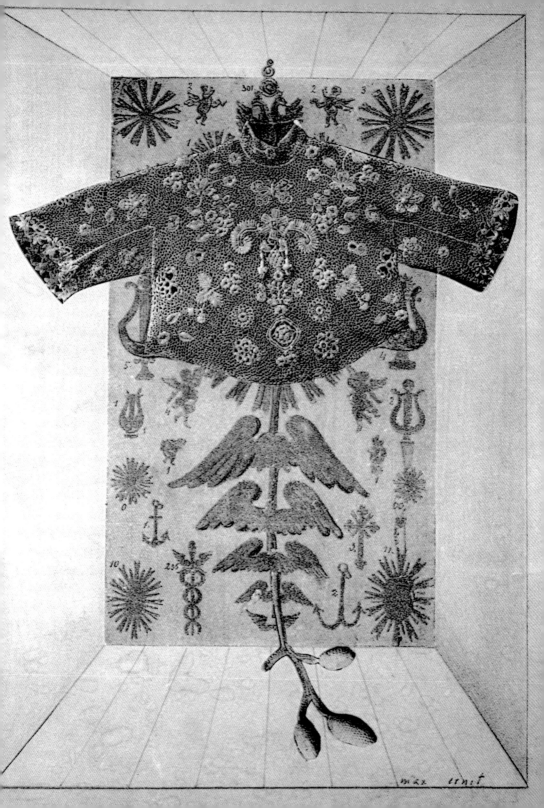

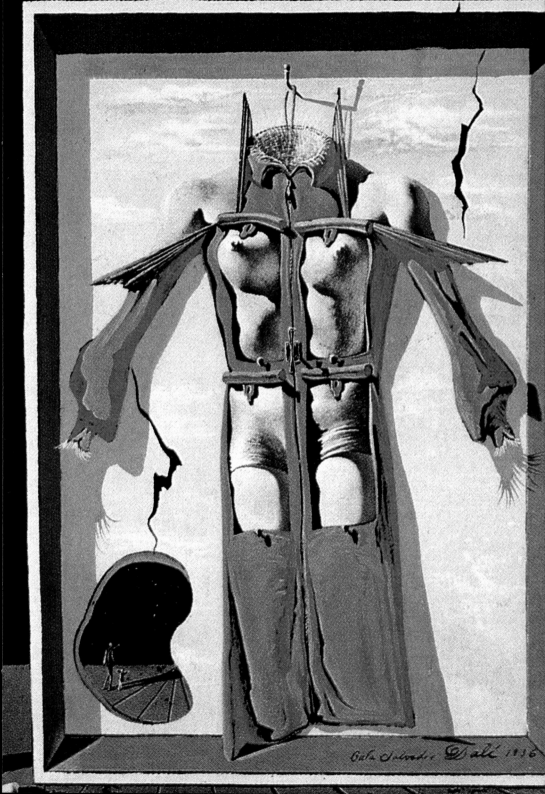

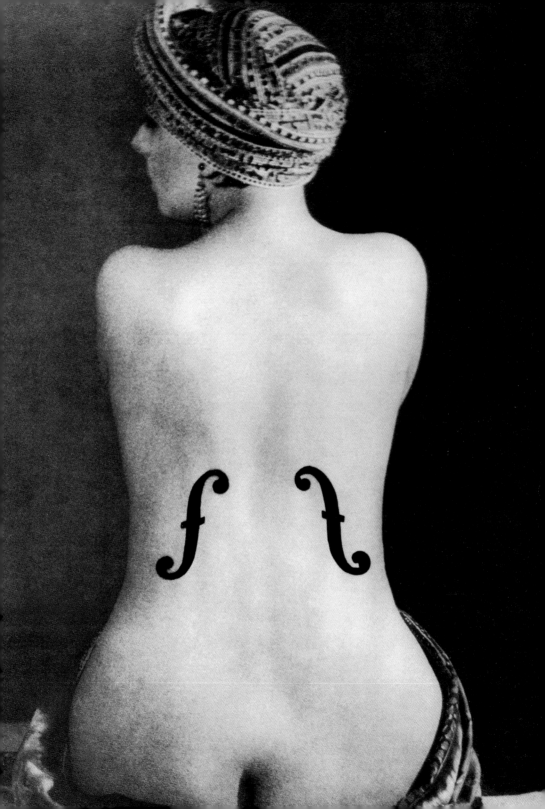

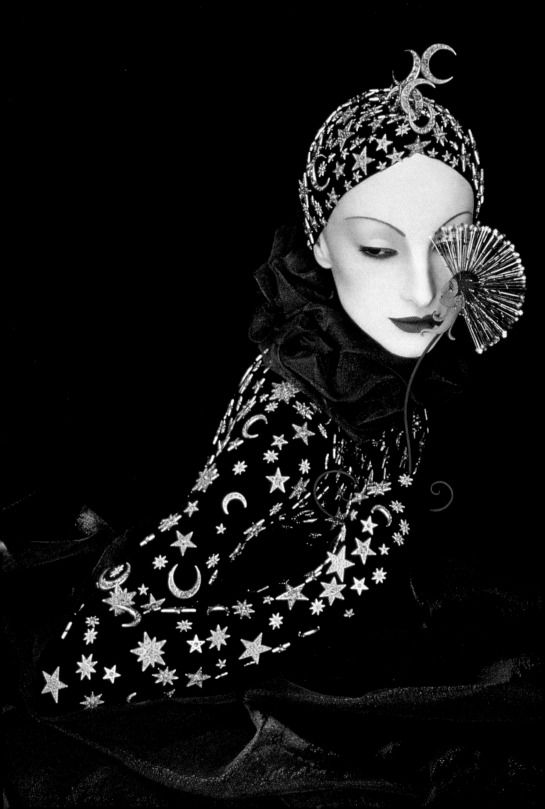

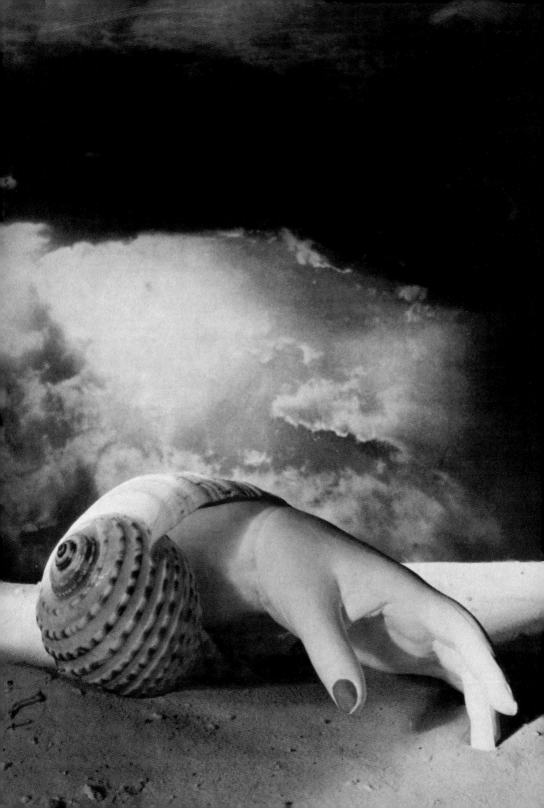

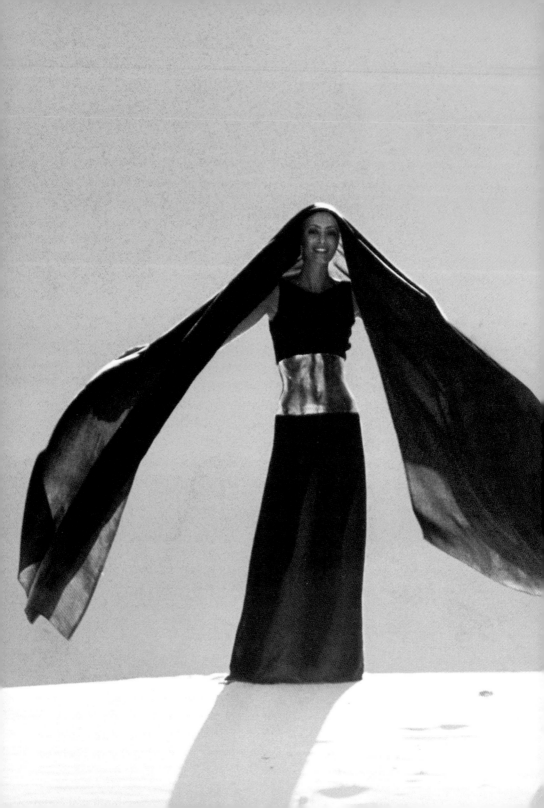

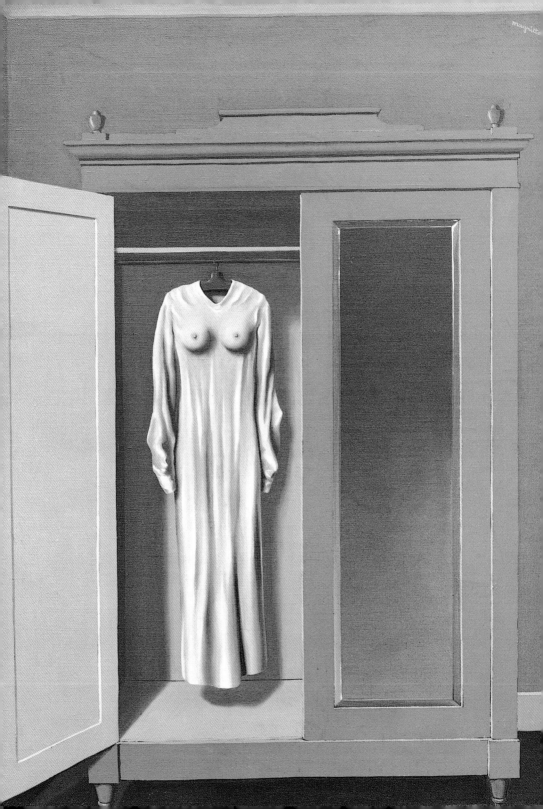

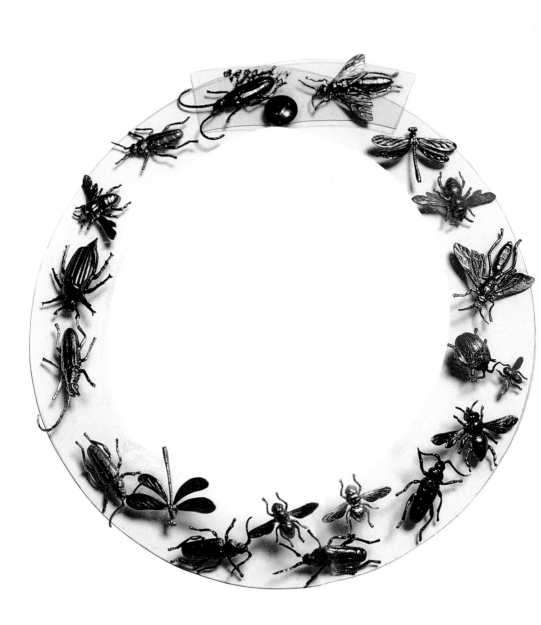

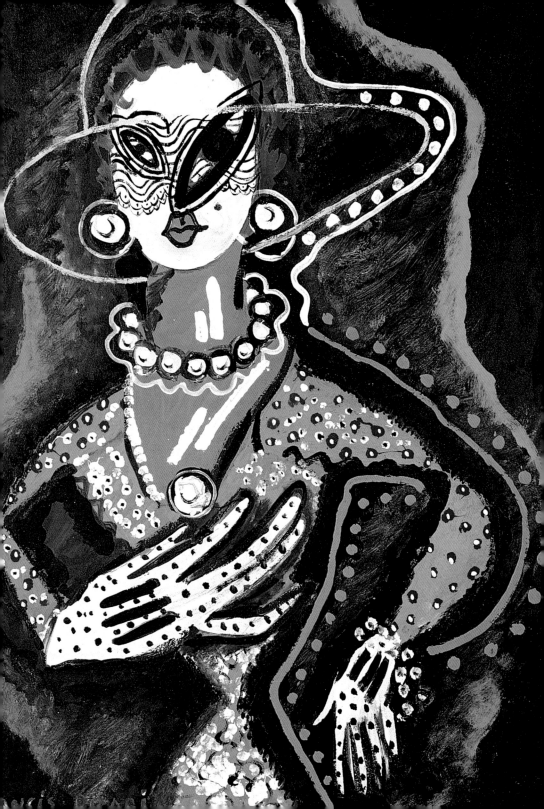

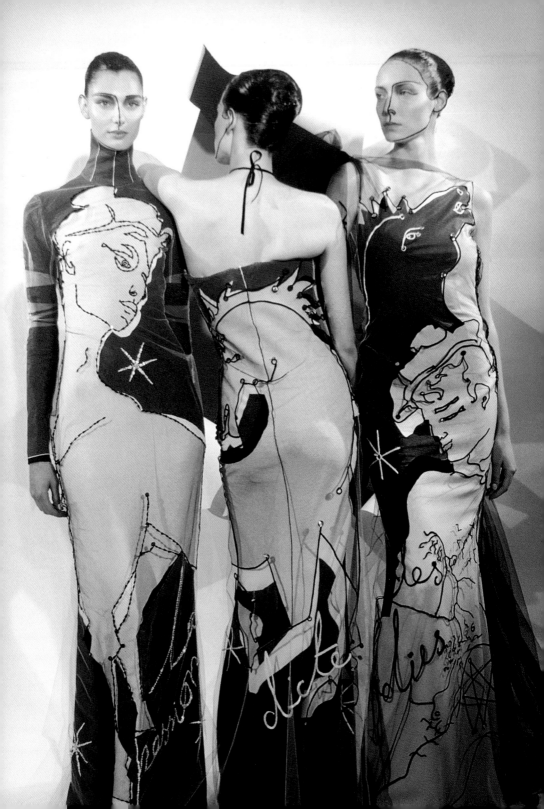

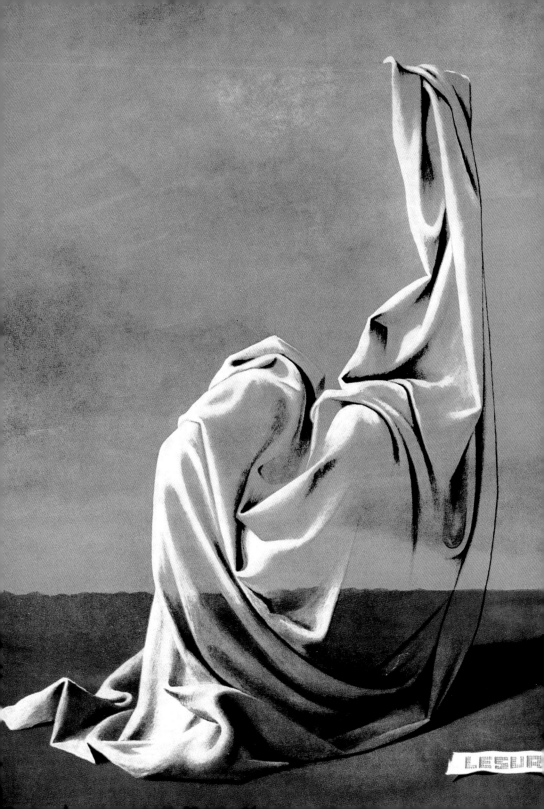

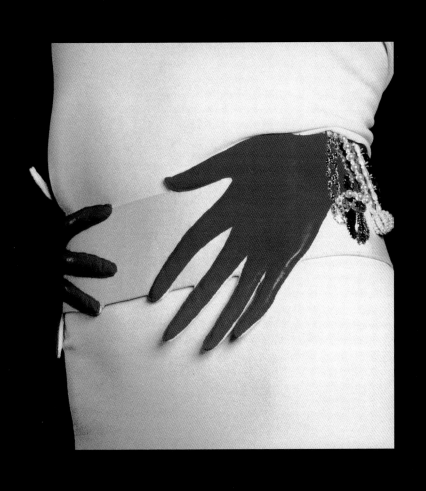

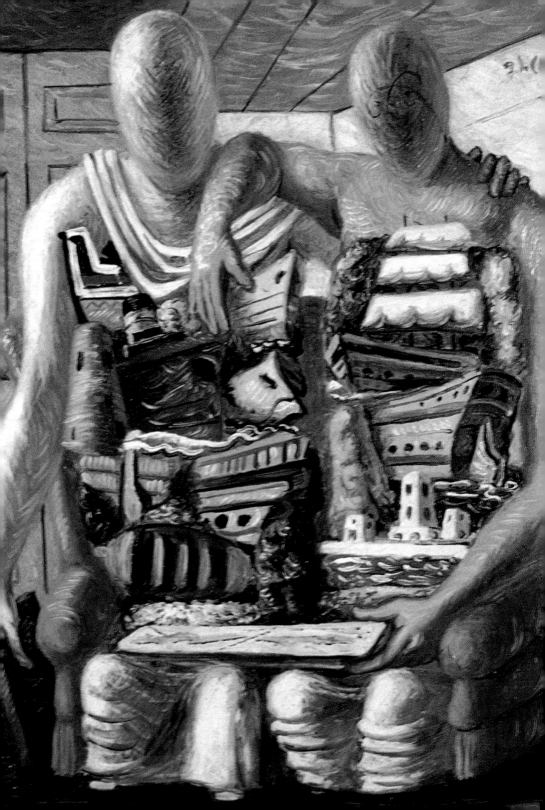

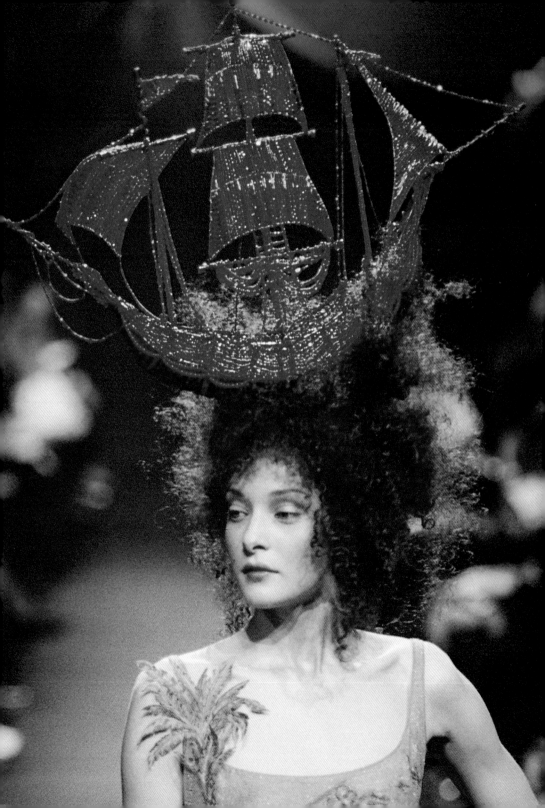

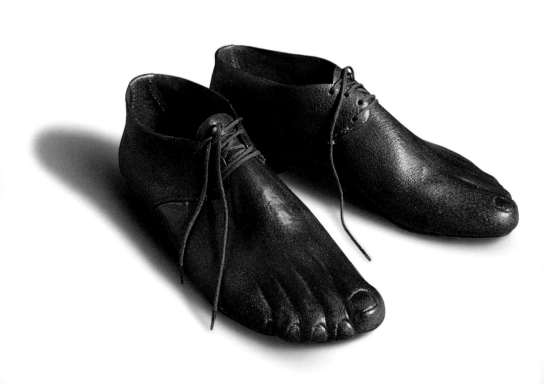

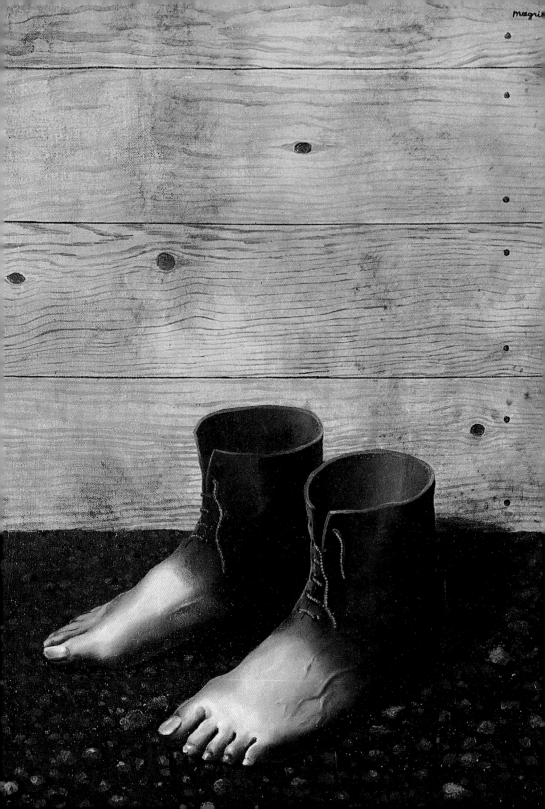

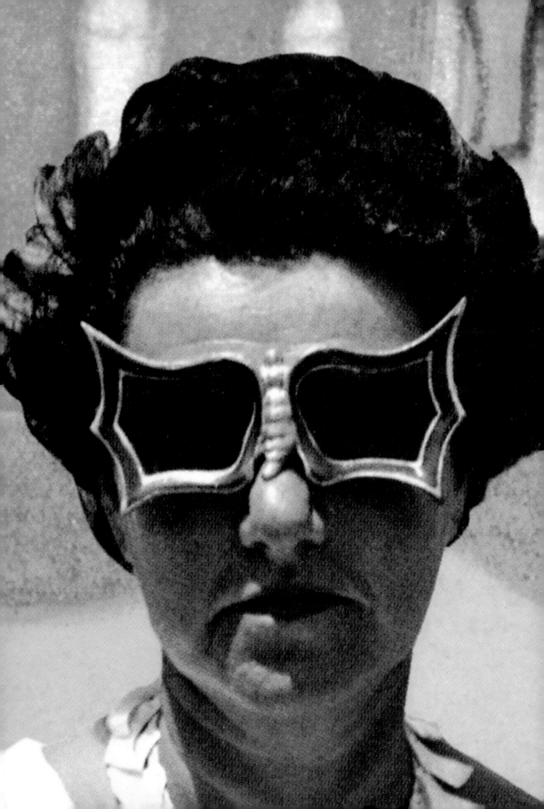

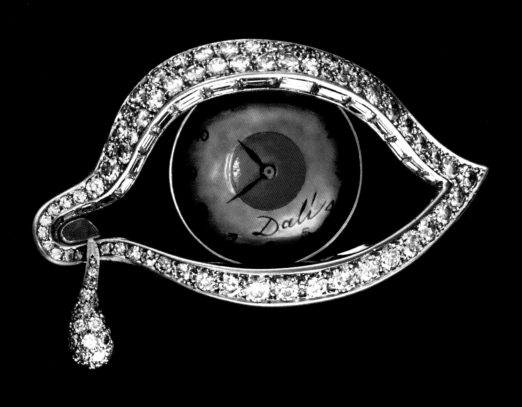

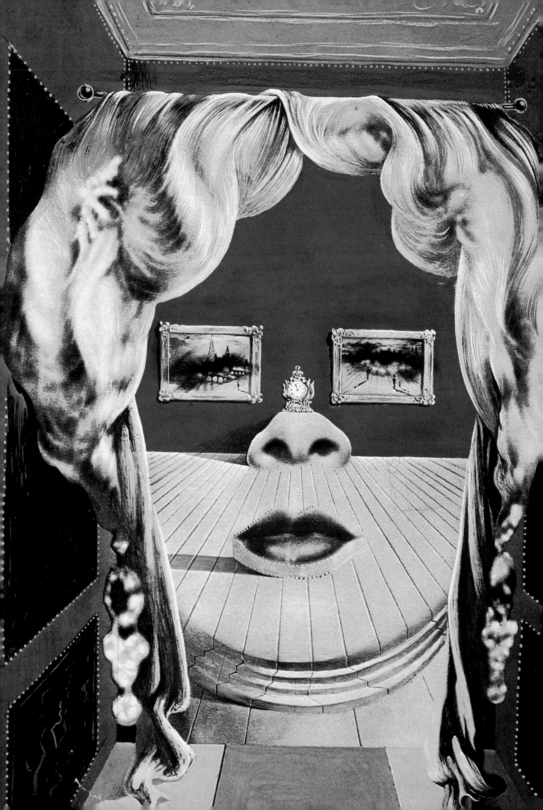

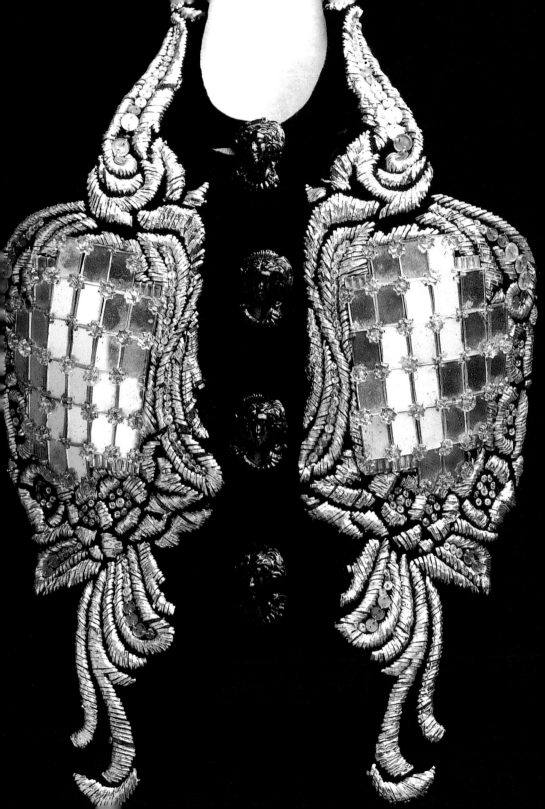

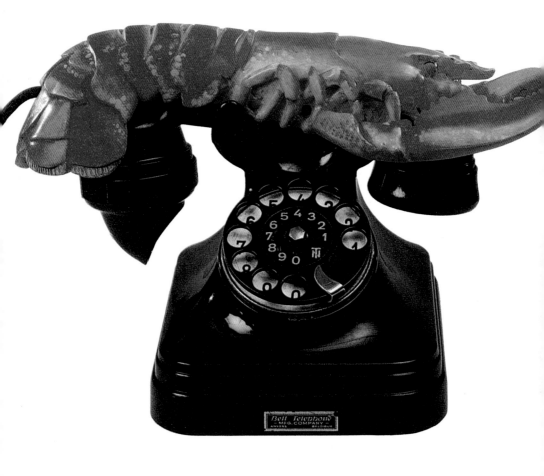

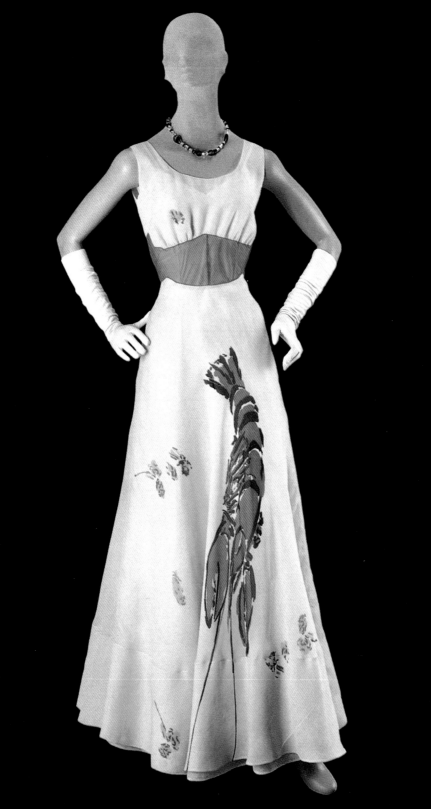

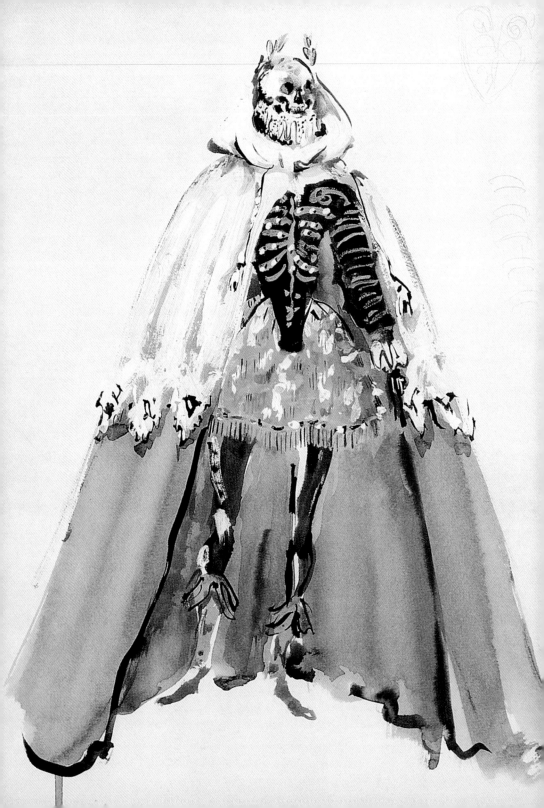

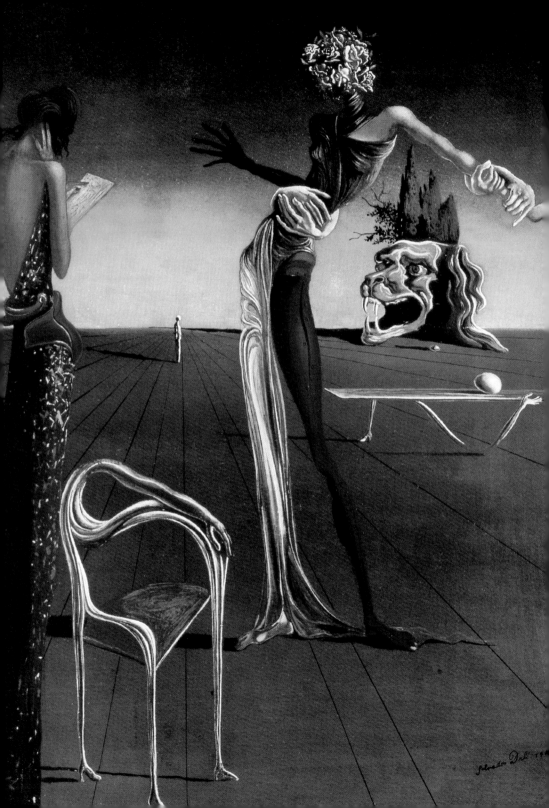

Salvador Dalí 19..

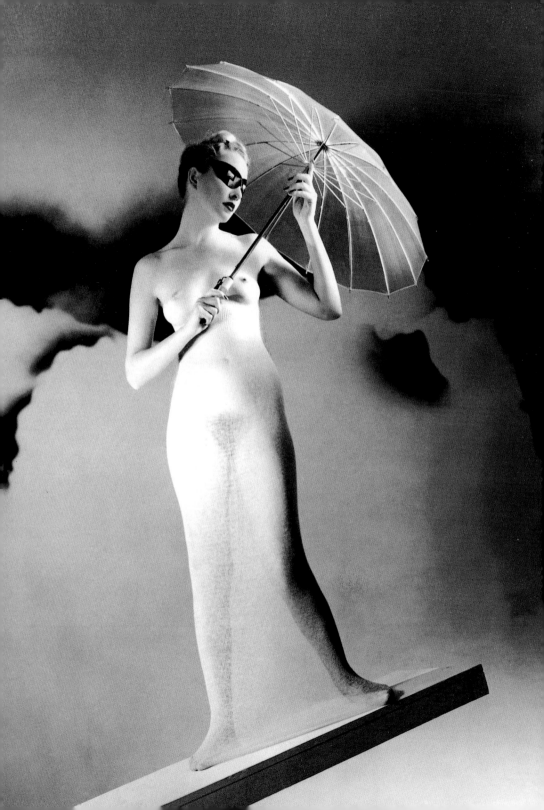

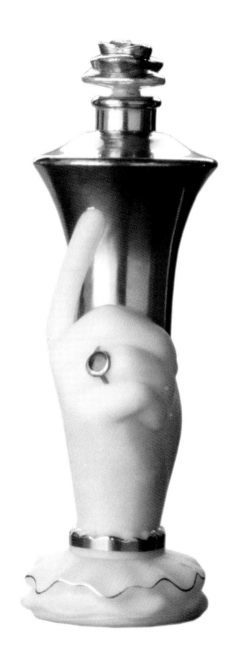

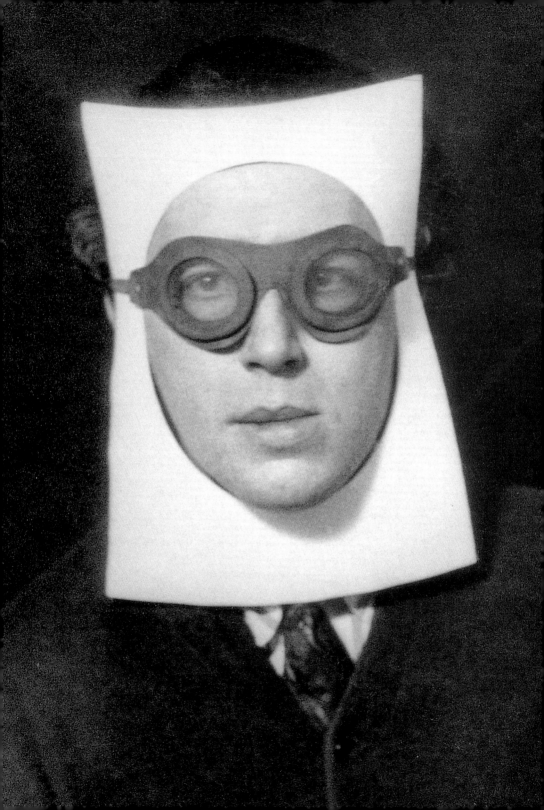

Chronology

1896: Birth of André Breton, founder of the Surrealist group.

1898: Birth of the painter René Magritte in Belgium, who adheres to Surrealism in the twenties.

1904: Birth of Salvador Dali at Figueras (Spain). He arrives in Paris in 1927 and soon establishes himself as one of the movement's most creative personalities.

1912-1919: Giorgo di Chirico (1888-1978) paints a series of works known as the "arcades," "mannequins" and "metaphysical interiors."

1920: André Breton meets Tristan Tzara and the Dadaists.

1924: Publication of Breton's *Manifesto of Surrealism*. The *Second Manifesto of Surrealism* is published in 1930.

1929: Max Ernst (Rhineland, 1891 – Paris, 1976) begins his collage-novels: *La Femme cent têtes*, followed, in 1934, by *Une Semaine de bonté*.

1930: Elsa Schiaparelli begins working in Paris. In 1935, she moves her couture house to 21 Place Vendôme. Several Surrealists produce designs for her.

1932: In Paris, Countess Peci-Blunt organizes a ball ("Bal blanc") at which many of the costumes were inspired by Surrealist themes.

1936: Jean Schlumberger meets Elsa Schiaparelli, for whom he designs jewelry and buttons influenced by the Surrealist movement, an experience which inspired his later work.

1937: Salvador Dali designs a sofa for Elsa Schiaparelli's showroom, whose shape is inspired by Mae West's mouth. The couturier launches her first perfume, *Shocking*.
In March, *Vogue* commissions Salvador Dali, Giorgio di Chirico and Pavel Tchelitchew to present the new spring fashions.

1938: Schiaparelli chooses the form of a woman loosing her skirt for the *Zut!* perfume bottle.
For the *Exposition international du Surréalisme*, store window mannequins are distributed to the artists for them to dress as they wish.

1939: The cover of the June edition of the American *Vogue* is designed by Salvador Dali.

2000: The Château Saint-Bernard at Hyères, built in 1923 by Robert Mallet-Stevens for the viscount and viscountess de Noailles, known as Villa Noailles and frequented by numerous Surrealists, becomes a public venue for fashion, art and design exhibitions and events.

André Breton photographed by Man Ray in 1933. © Man Ray Trust/Adagp, Paris 2002.

Fashion & Surrealism

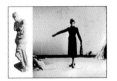

Salvador Dali, *Venus de Milo with drawers*, 1936. The artist spoke of a sort of allegory in which each drawer corresponded to a smell emanating from the body of a woman. Private collection. © Photo Descharnes/Demart Pro Arte B.V.
Elsa Schiaparelli, *Manteau bureau*, 1936. Cecil Beaton's surrealist-style photograph of this "coat-desk" with numerous real and fake pockets in the form of drawers. © Courtesy of Sotherby's, London.

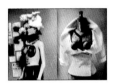

Exposition internationale du surréalisme, Paris, 1938. Store window mannequins were distributed to the artists for them to dress up as they wished. Here, Dali's, photographed by Man Ray © Man Ray Trust/Adagp, Paris 2002.
Jacket design by Silvano Malta in 1984, photographed with a newspaper undergarment by Alfa Castaldi. © Rights reserved.

The English artist Eileen Agan, wearing *Ceremonial Hat for Eating Bouillabaisse*, created in London in 1938. © Jenny Fraser/Estate of Eileen Agar.
Marie-Laure, viscountess de Noailles, photographed by Man Ray in the "fish skin" dress she wore to the "Bal des matières," given at her mansion in July 1929. © Man Ray Trust/Adagp, Paris 2002.

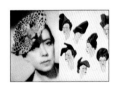

Elsa Schiaparelli wearing a real panther's head. At the height of her fame, in the late thirties, the couturier's eccentricities eclipsed those of her rivals. © Photo Piaz. Cacciapuoti collection.
Elsa Schiaparelli, hat designs, 1937, including Dali's "shoe hat," inspired by an idea of Gala's. © Ufac collection, Paris.

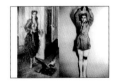

Dorothea Tanning, *Birthday*, 1942. The artist painted this self-portrait shortly after she met Max Ernst. Philadelphia Museum of Art. © Adagp, Paris 2002.
Man Ray, *Serge Lifar*. © Man Ray Trust/Adagp, Paris 2002.

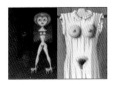

Victor Brauner, *Mitsi*, 1939. The Romanian artist (1903-1966) settled in Paris in 1930. A solitary person, his relations with the Surrealist group were episodic. Private collection. © Christies Images Ltd. 1998.
René Magritte, *Philosophy in the Boudoir*, 1948. The Belgian artist (1898-1967) created disconcerting images out of the trivia of everyday reality. Private collection. © Photothèque René Magritte/Adagp, Paris 2002.

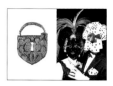

Lesage, embroidery motif for Schiaparelli. The couturier's favorite finery maker, François Lesage was able to exploit every facet of his consummate technique in his work for her. © Rights reserved.
Masked ball. Photograph taken by André Ostier at a ball given in the fifties by Baron de Rédé at the Hôtel Lambert. © Rights reserved.

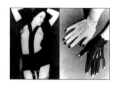

Man Ray, *Enslaved woman*, 1928-1929. The Surrealists' "official" photographer, the American artist Man Ray arrived in Paris in 1921 and for a long time divided his time between his personal artwork and working for various fashion magazines. © Man Ray Trust/Adagp, Paris 2002. **Man Ray, *Painted Hands*,** 1935. A photograph illustrating a point of convergence between fashion and Surrealism. © Man Ray Trust/Adagp, Paris 2002.

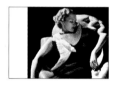

Marcel Rochas, *Seagull* bird dress, 1934. The Parisian couturier (1902-1955) designed this dress, photographed here by Harry Meerson, specially for *Harper's Bazaar* in April 1934. © Adagp, Paris 2002.

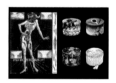

Salvador Dali, cover for *Minotaure*, 1936. This luxurious magazine, created by Skira in 1933, featured work by the Surrealists and other leading contemporary artists until 1939. © Photo Descharnes/Demart Pro Arte B.V.
Hat boxes (L. Fini, A. Brodovitch, A. M. Cassandre, G. de Chirico). For its 1937 spring number, *Harper's Bazaar* asked artists to design a hat box. © Mouron/Cassandre/Rights reserved/Adagp, Paris 2002.

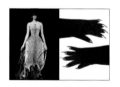

Jean-Paul Gaultier, Leopard dress, autumn-winter haute couture collection 1997-98. One of the most creative contemporary couturiers, Gaultier excels at using the most unlikely elements in his designs. © Archives Jean-Paul Gaultier.
Elsa Schiaparelli, gloves with gilded fingernails, 1935. One of the fetishist accessories in her 1935 winter collection, they went with a dress with the theme "Revolutionary." © Photo Chantal Fribourg.

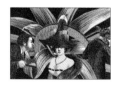

Max Ernst, *The Sap Rises*, 1929. Musée national d'Art moderne, Paris. © Photo Jacques Faujour/Cnac/Mnam/Rmn/Adagp, Paris 2002.

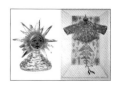

Salvador Dali, *Le Roy Soleil*, perfume bottle for Elsa Schiaparelli, 1945. Baccarat crystal and gold, blue and black enamel. ©Archives musée Baccarat, Paris.
Max Ernst, *The Transfiguration of the Cameleon on Mont-Thabor*, 1920. A painter, draftsman, sculptor and writer of German origin, Max Ernst (1891-1976) was one of the most prolific Surrealist artists. Private collection. © Photo B. Hatala/Centre Georges-Pompidou/Adagp, Paris 2002.

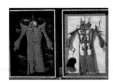

Salvador Dali, *Day and Night of the Body*, 1936. In this diptych, the Spanish artist sums up clothing's paradoxical purpose: to both hide the body and enhance it. Private collection. © Photo Descharnes/Demart Pro Arte B.V.

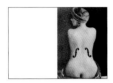

Man Ray, *Le Violon d'Ingres*, 1924. The figure of the model Kiki de Montparnasse, then the artist's mistress, immortalized in one of the very first Surrealist images. © Man Ray Trust/Adagp, Paris 2002.

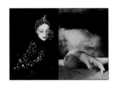

Serge Lutens for Shiseido, 1992. As artistic director of the Japanese brand, Lutens had complete freedom in designing the publicity material for Shiseido products. © Assouline/Rights reserved. **Dora Maar, *Untitled,*** 1933-1934. Picasso's muse for a time, she also flirted with Surrealism before succumbing to mental illness. Born Théodora Markovitch in Paris in 1907, she lived until she was ninety. Musée national d'Art moderne, Paris. © Adagp, Paris 2002.

Yves Saint Laurent, evening dress with a sculpted bust in gilded galvanized copper designed by Claude Lalanne, winter collection 1969. Like the breastplates of Antiquity, his sculpture idealized the female bust, both revealing and protecting it. © Manuel Litran.
René Magritte, *Homage to Mark Sennett,* 1934. Musée communal de La Louvière. © AKG Photo, Paris/Adagp, Paris 2002.

Elsa Schiaparelli, *Insectes* necklace, around 1937-1938. The transparent material gives the impression real insects are crawling around the wearer's neck. © Brooklyn Museum, gift of Paul and Arturo Peralta-Ramos. **Francis Picabia, *Woman Wearing a Monocle,*** 1924-1926. This painter of Cuban origin (1879-1953) was one of the Dada's most ardent proponents. His ideas were reused by the Pop movement and later by conceptual artists. Private collection. © Comité Picabia/Adagp, Paris 2002.

Surrealism revisited by Dior: Cocteau-style centaur motifs in black crepe inlaid in white crepe dresses, designed by John Galliano, Dior 1999 spring-summer haute couture collection. © Archives Dior. **Advertisement for Lesur fabrics,** 1946, by the illustrator Cassandre (1901-1968). Even without human presence, the drapery suggests the living figure and in doing so creates this enigmatic image in a typically Surrealist dreamlike landscape. © Mouron/Cassandre/Rights reserved.

Sandal in gold kidskin with a brass high heel reminiscent of the Pyramids. 1930. © Photo Massimo Listri.
François Lesage, *Hands* belt, 1986. Born in 1929, the last of the great Parisian embroidery designers created his own line of accessories reflecting the same taste for strangeness that inspired the couturiers in the thirties. © Archives Lesage.

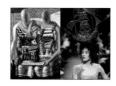

Giorgio de Chirico, *The Navigators,* around 1929. Private collection. © Photo B. Hatala/Centre Georges-Pompidou/Adagp, Paris 2002.
Jean-Paul Gaultier, *Marquise* ship headdress, 1998 spring-summer haute couture collection. © Archives Jean-Paul Gaultier.

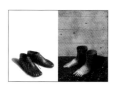

Pierre Cardin, man's shoes, 1986. In the pure tradition of ambiguity developed by the Surrealists, the great Parisian couturier, born in Italy in 1922, molded a man's foot. Museum of Fashion Technology, New York. © Photo Irving Solero/ Rights reserved.
René Magritte, *The Red Model,* 1935. Musée national d'Art moderne, Paris. © Centre Georges-Pompidou/Adagp, Paris 2002.

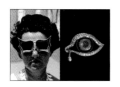

Peggy Guggenheim, friend and patron of the Surrealists, wearing extravagant butterfly sunglasses. 1968. © Rights reserved.
Salvador Dali, *L'Œil du Temps* (The Eye of Time), 1949. Watch set with diamonds and a ruby cabochon. This jewelry design by the creator of "limp watches" emphasizes the virtuality of time passing and makes it into the sixth sense of the modern world. Minami Art Museum, Tokyo. © Photo Descharnes/Demart Pro Arte B.V.

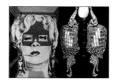

Salvador Dali, *Mae West's Face Which May Be Used as an Apartment,* around 1934-1935. The Art Institute of Chicago. © Photo Descharnes/Demart Pro Arte B.V.
Elsa Schiaparelli, jacket, 1939. Silk velvet embroidered with two gold and silver baroque mirror motifs. © The Metropolitan Museum of Art, New York, gift of Mrs. Pauline Potter, 1950.

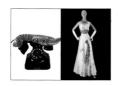

Salvador Dali, *Lobster Telephone,* 1937. The unexpected encounter of one of the most sculptural crustaceans with what in 1937 was still considered a technological marvel. Tate Gallery, London. © Photo Descharnes/Demart Pro Arte B.V.
Elsa Schiaparelli, lobster dress, 1937. The same year, Schiaparelli designed this lobster-inspired evening dress in painted silk muslin. Previously in the collection of the Duchess of Windsor. © Philadelphia Museum of Art, gift of Mme E. Schiaparelli.

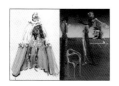

Christian Bérard, study for *Statue of the Commander.* Bibliothèque nationale de France, Paris. © Adagp, Paris 2002.
Salvador Dali, *Woman with Head of Roses,* 1935. A Mixture of erotic and morbid connotations, these scenes, with their metaphysical perspective, depict fashion model-like figures in Surrealist landscapes. Kunsthaus, Zürich. © Photo Descharnes/ Demart Pro Arte B.V.

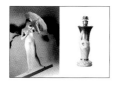

George Platt Lynes, *Helen Bennett with umbrella and mask,* around 1938. © George Platt Lynes II.
Baccarat bottle for Elizabeth Arden's *It's you.* 1939. Blown and molded opal crystal, decoration painted in gold and burnished with agate, ring painted with turquoise enamel, stopper molded in the form of a rosebud. © Archives musée Baccarat, Paris.

Editions Assouline would like to thank the Musée Baccarat, the publisher Jacques Damase, Robert and Nicolas Descharnes (www.daliphoto.com), Véronique Garrigues (Adagp), David Leddick, Serge Lutens, Soizic Pfaff, the Comité Picabia, and the fashion models Elena, Chrystèle Saint-Louis and Yasmeene for their help in producing this book.